Christofle

Endpages: Engraving of Christofle's Paris factory,
56 rue de Bondy, c. 1860 © Archives Christofle.

© 2006 Assouline Publishing
601 West 26th Street, 18th floor
New York, NY 10001, USA
Tel.: 212 989-6810 Fax: 212 647-0005
www.assouline.com

Translated from the French by Marguerite Shore

ISBN: 2 84323 657 6

Color separation: Gravor (Switzerland)
Printed by Grafiche Milani (Italy)

All rights reserved.
No part of this publication may be reproduced, stored in a retrieval system,
or transmitted in any form or by any means, electronic, mechanical,
photocopying, recording, or otherwise, without prior consent from the publisher.

Christofle

DAVID ROSENBERG

ASSOULINE

Pure, white, brilliant, noble material par excellence, since the dawn of time silver has conveyed universal symbols. Egyptian myths relate that gods' bones are made of silver and their flesh of gold. In Christian symbology, silver embodies divine wisdom. Associated with the lunar star and its name derived from a Sanskrit word meaning "white and shining," silver is a token of purity and purification.

The history of the silversmith's craft, which consists in working with this precious metal and transforming it to enhance its qualities, has been linked, up to the present day, with the Christofle name. Christofle silver has graced the tables of Napoleon and those of ministers and ambassadors, princes and maharajas, as well as those of ordinary families, less celebrated or wealthy. In the grand hotels of Monaco, London, New York, Cairo, or Alexandria, on board the Orient Express, the Trans-Siberian Railway, or transatlantic liners, people serve and honor their guests with settings by Christofle: a name that has now become a generic term, synonymous for the art of living "in the French manner."

While perpetuating the pioneering spirit of its founders, and rein forced by its one 175 years of expertise and excellence, Christofle has succeeded in expanding, over generations, to an international market. Since its creation in the mid-nineteenth century, the company has been a witness to and participant in the evolution of taste and customs, as well as different styles. From eclecticism and a return to classical style, Japanism, Orientalism, naturalism, Art Nouveau and Art Deco, to the latest design trends, Christofle has always been a creative and innovative force.

This living heritage originated with Charles Christofle, the company's founder. Born in 1805 to a family of small manufacturers specializing in crafting precious metals, the young Charles Christofle, at the age of fifteen, began working as an apprentice to his brother-in-law, Parisian jeweler Hugues Calmette.

Ten years later, he took over the jewelry business, and from 1830 on he became one of the most important jewelers in France; he employed approximately fifty specialized workers and found himself at the head of a prosperous firm whose work was known not only in France and Europe, but also in South America and Madagascar. The company produced jewels, metal fabric, silver filigree, decorations for French army uniforms (the very first pieces known to bear the Christofle stamp were the gilded buttons made to decorate French officers' uniforms), and special pieces for foreign courts.

Simultaneously a man of taste and a careful observer of advancements in the arts, sciences, and technology, as well as social developments, Charles Christofle knew that the new bourgeois class agreed with the message of François Guizot, then prime minister to King Louis-Philippe: "Frenchmen, enrich yourselves through work and savings!" But he also knew that this new class, desiring recognition and refinement, no longer wanted to keep its

money in silverwork, but preferred to invest in the stock exchange or industry.

In 1842, the young Charles Christofle acquired tools that would allow him to meet these expectations. A visionary captain of industry, he raised significant capital and received financial backing from his brother-in-law, Joseph Bouilhet, a bourgeois member of the Ancien Régime who was then living off a private income. Christofle convinced Bouilhet to purchase patents from the Englishmen Henry and George Richard Elkington and from the Frenchman Henri de Ruolz, which would allow him to carry out gold and silver electroplating on an industrial scale.

At the time, gold and silver plating of handcrafted objects entailed procedures that were both long and extremely dangerous. Goldsmiths worked with heated mercury, inevitably inhaling the lethal vapors. Now, thanks to new electrolysis processes, objects are simply dipped in vats; connected to the cathode of an electric battery, they are coated with molecules from a sheet of precious metal, which, connected to the anode, dissolve when subjected to an electric current.

but the use of this process led to numerous rivalries within the world of silversmithing, and only Odiot, renowned silversmith to Napoleon I, remained a faithful customer to the company. Although obliged by his commitments to Christofle, Henri de Ruolz tried to profit from the patent he had just sold; counterfeiting was likewise widespread. Charles Christofle responded with a long series of lawsuits, all of which were settled in his favor. Persevering over these difficult circumstances, in 1845—the date of the first true "silver-plate

production"—he registered his hallmark as a master silversmith. No longer content to do piecework, he decided to become solely a silversmith. The custom of having a dining room was spreading in bourgeois homes, and the family meal was becoming a privileged way of affirming one's social status. Quickly weighing the various markets that were open to him, Christofle understood the need to modernize and industrialize. At the same time, he gradually assumed control over all phases of production, from the processing of ores to the customer's table setting.

From then on, Christofle would produce silver plate (which would become the company's specialty) that equaled the beauty and splendor of solid eighteenth-century silverwork, but that cost much less. Emphasizing this activity, the company nevertheless decided to preserve a workshop that focused on special commissions and on solid silverwork. In 1846, Christofle received its first major official commission when King Louis-Philippe ordered a silver service for his residence at the Château d'Eu, in Normandy, for which Christofle responded by creating pieces in a simple, ridged design. A few years later, in 1851, Napoleon III commissioned services for the imperial châteaus in the Tuileries, Compiègne, and Saint-Cloud. His sumptuous taste also guided him in his choice of official gifts. He sent Maximilien de Hapsburg, emperor of Mexico, a sumptuous table service for 250 guests. Made up of 4,938 elements, including 16 candlesticks and no less than 60 components for the centerpiece, this service, like so many others produced at the time, reflected the era's eclectic tastes. The artists working for Christofle drew from the entire history of style in order to compose opulent designs: cupids, animal figures, lion heads, swan necks, vines, hooves, pearl necklaces, flowers, plants, and architectural motifs were intermingled and juxtaposed, sometimes to the point of decorative overabundance.

Silversmith to the King, Purveyor to the Emperor: fortified with these prestigious titles, Charles Christofle threw himself simultaneously into the conquest of the great trading centers of the Ottoman Empire, czarist Russia, the Kaiser's Germany, and the Austro-Hungarian Empire. In order to position himself in the latter two countries and to circumvent difficulties tied to customs constraints, he opened a factory in Karlsruhe (in Germany). In 1847, the first Christofle store opened on the Boulevard des Italiens in Paris, in the Hanover Pavilion, built by the Duke de Richelieu in 1760, in the garden of his home. This is the origin of the designation "pavilion," which Christofle shops have kept over time. In the spirit of Charles Christofle, artistic and industrial activity had to be passed on through a network of readily accessible stores, and exclusive partnerships were also developed, working closely with retailers to assure them significant publicity in numerous newspapers and public places. Thus, under the French Third Republic, this commercial network has spread throughout the world

Within a few years, Christofle became a brand name, and, indicative of the company's success, when describing silver-plated metal, people would henceforth say, "by Christofle."

at this time, the use of Russian-style table service was widespread and began to supplant so-called French-style service. It is said that this new custom of serving a meal, plate after plate, began at the table of Prince Kourakine, the Russian ambassador in Paris.

The etiquette of French-style service, first established under the reign of Louis XIV and then progressively refined until the eighteenth century, consisted of many separate and successive

table settings. Before the arrival of the guests, the hors d'oeuvres, appetizers, and soups were set on the table, symmetrically laid on both sides of either a display tray or an ornamental centerpiece (or *surtout*). Once the first course had concluded, dishes were removed and then replaced by the meat courses, roasted or grilled, and the fish courses. Later, everything disappeared to make way for the third and final service, which included fruits and cheeses, ice creams and desserts, sweets and petits fours. As for glasses and beverages, they were never placed on the table but rather on a large sideboard set aside specifically for them. If a guest wished to drink, he or she had to signal to a servant to bring a platter that held water and wine. It is worth recalling that wine was always served chilled and diluted with water. Moreover, people did not have individual glasses; glasses circulated among the guests after being rinsed between each use.

The French chef Urbain Dubois (1818–1901), who had apprenticed in the kitchens of the Rothschild family and had, among other things, served in Russia at the home of Prince Orloff, described the French table service in these terms: "The only objection that one might raise against this method, flattering for the eyes, is that the luxury of the table worked to the detriment of the cooking, insofar as the dishes displayed to the guests were difficult to keep sufficiently heated so that they might be savored under the best possible conditions."

The Christofle sales catalog published in 1862 attests to this progressive evolution of customs, and during a nearly twenty-year period, from one publication to another, page after page, one finds utensils shown, side by side, for both "French" and "Russian" service. These commercial publications also indicate the evolution of eating habits resulting from the invention of canning and the development of railroad transport, which made it easier to supply cities with fresh foods.

Within a few years, new pieces were introduced for everyday or for special use. Christofle presented his customers with innumerable items, such as platters for beef, grilled turbot, and as a prelude to a fine meat, cases of quail. It was possible to outfit oneself with spoons for coffee, chocolate, eggs, mustard, olives, soup, stew, sauce, sugar, and strawberries. Likewise, there were spoons for beer, punch, fruit, and syrup; spoons for water glasses; for absinthe, milk spoons for sale in Germany; powdered sugar spoons in Brazil; ice spoons in Turkey, and spoons for steeping herbs in mulled wine. The list goes on, with sugar tongs; fish servers; carving platters and platters for game and salad; serving implements for pie, ice cream, candy, and salt; oyster forks; melon forks; pickle and snail forks; a marrow pick; an asparagus cradle with spring-loaded tongs; leg-of-lamb sleeves; cutlet and ham sleeves; nutmeg graters; grape scissors; nutcrackers; tea strainers; bread baskets; cake baskets; ice buckets; crystal cruets; revolving trays; liqueur trays; wine trolleys...

Knife handles could be round, cap shaped, grooved, or cane patterned. Decorative motifs were known as wheat ears, ivy leaves, rocaille, Louis XIV, Louis XV, Louis XVI, Louis XVI rosette, baguette, garter, escutcheon, ribbed, and palmette, lion's claw next to floret tips, shells, tulip violin, Spanish fillet, English fabric, Dutch, German, and Medici. Some pieces were decorated with pearls and ribbons, knurled palmettes, fluting, and edging. The diversity of designs and styles was in step with the diversity of the arts in the nineteenth century, and the female figure, nude or dressed in the style of antiquity, sometimes lascivious, sometimes formal, once again became a great source of artistic inspiration.

There were oval and round dish covers, casseroles, vegetable saucepans, tureens; the tops of dishes gave rise to a plethora of motifs: azaleas, daisies, bindweed, hollyhocks, nasturtiums,

tomatoes, and artichokes, but also partridge, ducks, geese, squirrels, rabbits, hens, fish, pheasants, resting deer, boars, mountain sheep, and sleeping goats. Likewise, there was an entire gallery of figurines: the dancer, the drinker, the milkmaid, the farmer's wife, the gardener, the cook. If one wished, one could also embellish a lid with an allegory of concord or discord. To complete a service, Christofle offered many candlesticks, torches, candelabra brackets and candelabra, plate warmers heated by water, candles, or wine spirits, as well as ashtrays for cigars, napkin rings or clips, silent butlers for collecting table crumbs, table brushes, menu holders of ebony or ivory, liqueur labels, bells, and toothpick holders.

Finally, it was possible to order travel items and other articles described as being "for the *levant*," conceived for an Eastern clientele or those enamored of Orientalism: Persian hookahs on tripods, Turkish ashtrays, perfume burners, Arabian coffeepots, to name a few.

In the fashion of the canvases of Ingres or Delacroix, or the sculptures of Carpeaux, the Christofle object embodied and celebrated the spirit of the nineteenth century. In 1863, Charles Christofle died, leaving behind an industrial and commercial empire, as well as a human and artistic legacy. There was already a long list of prizes and awards he had received on the occasion of world exhibitions, fairs, and salons. The introduction to an illustrated sales catalog, published shortly before his death, makes it clear that there is a constant emphasis on artistry, integrity, and love of well-crafted work. For Charles Christofle, more than being a business, silversmithing was the art of embellishing hospitality and conviviality. Paul Christofle, his son, and

Henri Bouilhet, his nephew, took over the company. The latter rejoined the company after graduating from the Ecole Centrale des Arts et Manufactures, in 1852. Both an engineer and an artist, Bouilhet would become one of the founding members of the Union Centrale des Arts Décoratifs.

One of Bouilhet's first important contributions was to develop the industrial use of the electroplating process, a technique that made it possible to obtain a shape through an electrolytic deposit on a mold made from gutta-percha (a type of latex) covered with graphite to make it a conductor of electricity. Thanks to this process, Christofle went on to open up new markets. The company created the monumental bronze doors for the Church of Saint-Augustin, with plans designed by Louis-Pierre Baltard; the doors and glass canopy for the Paris Chamber of Commerce; the doors for the law school on rue Saint-Jacques; the facade for the head office of Messageries maritimes; and the decorative scheme created by Alphons Mucha for the Fouquet store on the rue Royale. Christofle also provided decorative bronzes and designed prestigious pieces of furniture, such as thrones, and a piece incorporating the Rossigneux jewels, presented to the public on the occasion of the 1873 World's Fair in Vienna. This unique piece combined very different techniques: painted, cloisonné, and translucent enamels, inlays, damascening, colored gilding, and various patinas.

Christofle moreover created special commissions, such as the monumental groups that ornament the roof of the Garnier Opera in Paris, or the statue of Notre-Dame-de-la-Garde in Marseille, unveiled in 1870. A true technical feat, it is still the largest electroplated sculpture in the world. The vats

needed for its fabrication each contained 70,000 liters of liquid, and each mold weighted nearly one and one-half tons.

In 1882, working under conditions of the strictest anonymity, a nawab contracted Christofle to make an extraordinary bed, a commission that was fulfilled for the sum of 80,000 gold francs. The order was worded as follows: "A bed in dark wood fitted with silver appliqué with gilded portions, monograms and coats of arms, embellished with four life-size figures in bronze, painted a light color and coiffed with real hair, with eyes that move and arms carrying fans and horse tails; the bed must contain harmoniphone music with eight tunes, six cheerful and two melancholic." Silversmiths, cabinetmakers, designers of automatons and music boxes, as well as a painter, a sculptor, and a hairdresser—all among the most renowned of their time—collaborated on the creation of this piece.

The life-size painted bronzes concealed mechanisms that produced delicate movements of the eyes and hands. Nearly 640 pounds of solid silver, worked in repoussé and carved in the form of leafy garlands and foliage in relief, embellished the rosewood frame.

During this same period, with the use of electricity spreading through city streets and apartments, Christofle created decorative pieces adapted to this new technology: lamps, illuminated candelabra, or jardinières combined with silver and opaline.

Nor did Christofle neglect rural France, and within a few years he became the top award-winning craftsman at competitions in the countryside. These events, which had existed since 1844, became official in 1891.

Whether Rouillard, Moreau, or Mallet, Christofle called upon the most renowned animal sculptors and naturalists. Indeed, Christofle's association with the great artists of the time would

become one of the most distinctive signs of the culture of this company, which continues to perpetuate this tradition today.

henri Bouilhet and Paul Christofle went on to develop numerous other techniques. They modernized the guilloche process, using mechanical engineering and electricity. They were determined to update the ancient technique of cloisonné, reviving it with Byzantine and Far Eastern traditions. They also experimented with numerous processes for inlay and chemical patinas and perfected colored gold, obtained through electroplating. These precious pigments were applied to objects, using a technique whereby spaces are created in the metal and then outlined in gouache or enamel, resulting in truly decorative compositions. Chemical patinas offered the possibility of recovering the tints and effects of Chinese and Japanese bronzes; these techniques would be employed particularly for the production of pieces in the copperware collection produced by Christofle at the close of World War I. Henri Bouilhet likewise perfected the technique of damascening through electroplating, which made it possible to inlay gold, silver, or copper wire over a metal sheet, using acid and electricity: the designs were delimited by a layer of enamel. The piece was then dipped in an acid bath that corroded the unglazed portions. A second bath of silver or gold allowed the colored metal to be deposited and affixed to the corroded portions. The Christofle workshops still used the technique known as *mokoumé*, a Japanese term for the laminating and hot work of a group of different metals. The decorative result resembled a sort of marble or veined wood. In the same spirit of naturalistic effects,

Christofle perfected the technique of "natural impressions," obtained by hammering metal directly onto tree or plant leaves.
From the beginning, Christofle had a presence at World's Fairs, as well as at French and international salons. In 1851, during the first World's Fair in London, Christofle received the grand prize. The flyleaf of the company's sales catalog of 1862 lists nearly thirty medals and awards. At the 1867 World's Fair in Paris, Christofle attracted the attention of visitors with a series of Japanese-inspired pieces using the technique of cloisonné enamel. Emile Reiber, a discriminating connoisseur of Asian art, was then head of the company's creative department. Collaborating with the latter, Henri Bouilhet designed rural motifs embellished with the delicate silhouettes of birds, rabbits, and fish. Christofle was no longer content with copying styles; he had to adapt, invent, and expand his sources of inspiration, opening his mind, for example, to Persian art. In 1880, at the Metal Arts Exhibition in Paris, Christofle presented the first "natural impressions" pieces and unveiled a remarkable coffee-pot designed by the sculptor Albert-Ernest Carrier-Belleuse, where the lines and style announce Art Nouveau. Christened *"L'Union fait le success"* ("Success Through Unity"), the piece, created by the two studio heads Broeckx and Troté, the silversmith Heintze, and the engraver Roze, won prizes on numerous occasions. Twenty years later, on the occasion of the 1900 World's Fair, Christofle created a sensation, showing, for the first time, the Pivoine (Peony) electric lamp, a masterpiece of Art Nouveau, where the opaline globe is blown right onto the mounting. Christofle left its mark on every principal artistic trend of its time: Japanism, Orientalism, naturalism, antique style, Renaissance, Art Nouveau, and Art Deco; there was no stylistic movement that did not have room for innovations and technical inventions, and consequently, there was no technical development that failed to bring

forth one or more new styles. And so the company precisely resembled the man who was at the helm: a man equally artist and scientist, contributing to the mutual advancement of the arts and sciences.

In 1860, at the other end of the world, the Frenchman Jules Garnier made a mining discovery of utmost importance. In New Caledonia, he had just unearthed one of the largest deposits of nickel in the world. Sixteen years later, seeing new exploration opening up, Christofle entered into an exclusive agreement with Garnier for the mining of this ore, because until that time the business had depended on English and German suppliers who, because of the scarcity of the ore, charged extremely high prices.

As business grew, Christofle in fact became a significant consumer of electricity and metal. The company's signatures pieces required the use of silver, nickel silver (an alloy of nickel, copper, and zinc) for the production of cutlery, brass (an alloy of copper and zinc) for large pieces of silverwork, aluminum (which originally was much more costly than gold or silver), tin, steel, and gallia (a tin-based alloy) for the creation of Art Nouveau objects.

Thanks to a new factory that opened in 1876 in Saint-Denis, Christofle, from that point on, oversaw all phases and aspects of production, from the processing of ores to the marketing of products. The company's industrial tools allowed it to respond to new requests, notably those inspired by the expansion of rail and sea travel and the creation of luxury hotels.

Beginning in the mid-1860s, Christofle equipped the *Péreire* and the *Impératrice Eugénie*, which were among the first French

transatlantic steamships. Next came the *Provence* (1906) and the *France* (1912), precursors to the great luxury liners from the period between the two World Wars: the *Île de France* (1927), the *Atlantique* (1930), and above all the *Normandie* (1935), for which Christofle created a 45,000-piece service in the purest Art Deco style. The company likewise equipped the Orient Express and the carriages for the Trans-Siberian railroad and for the Compagnie Internationale des Wagons-Lits. Christofle also filled commissions for luxury hotels; the Hôtel du Louvre (1855) and the Grand Hôtel (1862, Place de l'Opéra) were among the company's very first clients, followed by the Ritz, Crillon, Meurice, Lutétia, and George V hotels in Paris; the Martinez, the Negresco, and the Hôtel de Paris on the Côte d'Azur; the Adlon in Berlin; the Ritz and the Carlton in London; and the two Savoy hotels in Cairo and Alexandria.

During World War I, Christofle participated in the effort to supply the French army with cartridges. At the end of the conflict, Europe's spiritual, political, and economic landscape was shattered. The ancient Austro-Hungarian Empire was dismantled, the Russian Empire was no more, and Germany lay in ruins. Also, in order to skirt the widespread hazards of protectionism, Christofle opened factories in Switzerland, Italy, and Argentina, but unfortunately the economic crisis of 1929 put a brutal stop to this rebuilding effort.

Named head of the company in 1932, Tony Bouilhet, grandson of Henri Bouilhet, would preside over the restructuring of Christofle. He brought together the essential elements of industrial production at the Saint-Denis location, while establishing the company headquarters in a building located at 12 rue Royale in Paris; Carla Borletti, his wife, oversaw the transformation. Born into an important manufacturing family from Milan, she was responsible for,

among other things, the concept of the Christofle Pavilions. True ambassadors for the brand, which now had a worldwide presence, these stores presented all the available merchandise, offering personalized decorating advice and specific services: Haute Orfèvrerie, made-to-order, and the Christofle bridal registry.

In 1925, all the major jewelers were present at the great decorative arts exhibition in Paris. In a pavilion designed by Georges Chevalier, Christofle showed its latest creations made in association with Baccarat crystal works. The quintessence of Art Deco, this pavilion also included bas-reliefs by Edouard Chassaing, paintings by André Mare, and pieces by André Groult and architect Louis Süe, who some years later would design a line of table objects.

Christofle then called upon the most significant artists of the *"Années Folles"* (the Roaring Twenties). Luc Lanel, artistic director of Christofle from 1922 to 1942, created the Transat line for the *Normandie,* characterized by curved shapes and handles, bowl-shaped salt and pepper shakers, plates embellished with a simple, thin line, and cutlery with an elongated design.

Christian Fjerdingstad, a Danish artist and silversmith who worked for Christofle from 1924 to 1940, created much of its Art Deco collection. He worked with refined shapes, smooth or hammered, mixing precious metals, woods, horn, and ivory. Extremely gifted, he subtly combined and assembled organic and geometric shapes, such as the Swan sauceboat, a model still in production, where the spoon evokes the infinite grace of this bird's neck.

The Italian architect Gio Ponti, who received the grand prize at the International Exhibition of Decorative Arts in Paris in 1925, began his collaboration with Christofle with his design for the Flèche (Arrow) candelabra (1928), made up of two cornucopia in the shape of a heart, intersecting around an arrow. With a novel combination of neoclassicism and geometric abstraction, the style of the radically innovative piece clearly foreshadows design trends from the second half of the twentieth century. Ponti also built Tony Bouilhet's house in Garches, in 1927.

During World War II, while the Christofle factories were impounded by the German occupying forces, Tony Bouilhet managed to maintain minimal operations, setting up a facility for the repair and restoration of silverwork. He came up with the idea to join forces with renowned artists such as Man Ray, Hans Arp, Jean Cocteau, and André Masson to create editions of porcelain and painted plates. Produced in limited numbers, these plates were shown to the public on two occasions, during the Occupation and after the Liberation, in 1951. Representing a collection of 150 pieces, they are now in the Bouilhet-Christofle Museum in Saint-Denis.

The 1950s, which marked a return to prosperity, were accompanied by intense artistic and commercial activity for Christofle. Gio Ponti, Tapio Wirkkala, and Lino Sabattini set the tone in matters of design. One of the most widely regarded artists and industrial designers in Finland, Wirkkala created the Duo cutlery pattern for Christofle. Sabattini, a silversmith and student of Ponti, was, like the latter, one of the great Italian designers of the 1950s and 1960s. Head of Christofle's studios in Milan from 1956 to 1963, he designed much of the Formes Nouvelles line, including the Como tea services. With its clean lines and dynamic shapes, the Formes Nouvelles catalog, published in 1959, confirmed the

predominance of Italian and Scandinavian design, putting them together in a perfect synthesis of the era's taste.

Albert Bouilhet had been appointed by his father, Tony, to supervise the establishment of a factory and a new branch of Christofle in Argentina in 1952. Beginning in the 1960s, and particularly during the 1970s, he took the initiative to open numerous production and distribution facilities abroad, in Italy, Brazil, Argentina, Belgium, Germany, and the United States. He also started an ultramodern factory, dedicated exclusively to the production of cutlery. Built in Yainville, France, and based on plans by his brother, the architect Henri Bouilhet, this new site, which opened in 1971, could produce up to five million pieces of cutlery annually.

Henri Bouilhet, who beginning in 1959 assumed control over the Christofle brand and production, went actively in search of contemporary and refined models. For his part, Albert received an award for excellence in exporting in 1976. Having become leaders in their areas of activity, Albert, Henri, and their brother Marc Bouilhet then made Charles Christofle's dreams a reality: achieving international fame and producing a product of irreproachable quality, destined for both sumptuous tables and the wider public.

During this decade, Christofle became familiar with trends in geometric art and published the contemporary Christofle catalog. Metal, sometimes in conjunction with colored plastic materials, was used to create pieces where refined geometries were formed, almost exclusively with circles and squares. A great lover of modern and contemporary art, France's president Pompidou selected the Mercury service for the presidential airplane. In the 1980s, Christofle launched the Perspectives collection, a limited edition of silver pieces. At that time, the company worked with

artists such as Jean-Michel Folon and Pierre Arman, and with figures such as Claude Picasso.

This project has continued to the present day, with artists such as Michele Oka Doner, an American designer who draws inspiration from nature to create engraved pieces (vases, centerpieces, and a pedestal table) based on the palm leaf. Clara Halter has designed the Egg of Peace (2000), a sculpture covered with the word *peace* engraved in many different languages. And to celebrate the passage to the third millennium, Roger Tallon, designer of the TGV, the French high-speed train, created the Pyramidion, a pyramid of silver, on whose surfaces the major events of the past 2,000 years are chiseled in three languages. The upper portion is left free from any inscription, ready to receive history's new episodes.

Silver, a precious metal, remains the means of expression and the greatest source of inspiration for Christofle. All its aesthetic, symbolic, and physical qualities (purity and durability) have evolved through objects that, while exceptional and luxurious, are compatible with everyday use. Christofle is ceaselessly perfecting exclusive technologies to facilitate silver's daily use and care. Today, the production techniques employed are such that the pieces require only extremely basic care, making "polishing duty" a thing of the past. Whether crystal, porcelain, or silver plate, Christofle now produces only renewable product lines that share the values of the grand silver services the company once offered exclusively, meant to last forever.

At the dawn of the twenty-first century, and following the example of haute couture, Christofle is perpetuating the concept of haute orfevrerie. Put into practice in the studios, this activity makes it

possible to reissue prestigious pieces that are part of the company's historic legacy (on display in the Bouilhet-Christofle Museum), as well as to craft unique or custom objects whose creation constitutes a challenge that is both technical and aesthetic. The timeless Como tea and coffee service created by Lino Sabattini in 1957, which combines raffia and metal, at the time an innovative approach, was, for example, reintroduced in a limited and numbered edition, as was the Gigogne coffeepot created by Christian Fjerdingstad in 1926.

In addition to this exceptional production, Christofle has, above all, remained faithful to the spirit of its founder's love for modernity and innovation. For this reason, the company's silver pieces more than ever reflect current trends in contemporary design. Elisabeth Garouste and Mattia Bonetti have created the Ovide collection (2004), a vase and centerpiece made from an openwork web, elegant as a polished gem. Designer Martin Szekely has created the Reflet collection (2001), a minimalist series of four pieces of solid polished silver—trays, small dishes, and boxes—transformed into elegant "object-mirrors." He then designed the Ténéré cutlery (2004), notable for its sensual and undulating form and now one of Christofle's best-selling items. There are also new household objects: architect Gae Aulenti conceived the Métropolis collection (2001), a series now on display at the Bouilhet-Christofle Museum, which consists of five pieces for everyday use: table mats, a cheese tray, a hot plate, a carafe coaster, and an ovenproof dish. A contemporary play of textures alternates with smooth, reflective surfaces and a mat with an openwork "metal weave." American designer Adam D. Tihany has created the 3000 collection (2000)

—glasses, cocktail shaker, champagne bucket, ice bucket, and all the accessories for cocktails—combining glass with the gleam of silver. He then created the Urban cutlery pattern (2004), with sculptural and faceted lines.

Andrée Putman has created a complete collection for the table, entitled Vertigo (2002), which stands out for its simplicity of ornament: a ring with an asymmetrical design that appears on each piece. This distinctive sign, associated with Vertigo's success, recently reappeared with 925 (2005), her first collection of jewelry in solid silver for Christofle. The ring, which combines "modernity, glamour, and timelessness," is available in the form of elegant necklaces, pendants, loop earrings, rings, and cuff links. Christian Biecher, inspired by the creations that Gio Ponti and Christian Fjerdingstad made for Christofle in the 1930s, has designed the Drop cutlery pattern (2005), characterized by an oblong line in the shape of raindrop, a tableware design for the twenty-first century. Christofle, which has always been attuned to the evolution of culinary taste and customs, also seeks advice from the new masters of gastronomy. Today's table is adorned with a dessert fork, known as the *fourchette à gourmandises,* by Pierre Hermé; vegetable cutlery by Alain Passard, and the K+T cocktail line by American chef Thomas Keller. As time goes by, Christofle continues to stand out for the added sense of soul and spirit with which it imbues all its creations. From innovative objects, whether for the table or for personal decoration, to elements of decor, whether by renowned or emerging designers (artists, designers, architects, and great chefs), the company is redefining the idea of everyday luxury. Adam D. Tihany, Andrée Putman, Christian Biecher, Taher Chemirik, Dögg Design, Savinel & Rozé, Jean-Marc Gady, Sam Baron, Ora-Ito—soon to be joined by other prestigious names—are infusing new work with their creativity. The art of the silversmith of the future is emerging.

Glossary

Base: End of flatware handle.

Burnishing: Finishing work consisting of rubbing the surface of the metal with an agate or steel head (burnisher) in order to give it a warm, shiny appearance.

Champleve enamel: Technique generally employed with copper, using burin to create cavities that are then filled with colored enamel, which is glazed by firing. The remaining portions can be gilded with a mercury or electroplated.

Chasing: Decorative technique of hammering the metal with a chisel struck by a small hammer. The design generally appears on the reverse of the metal plate or leaf.

Cloisonne enamel: Technique of applying metal strips to a gold, silver, or copper plate, with the strips delimiting shapes that will later be filled with enamel.

Collar: The part of a piece of flatware that connects the handle to the blade, to the spoon bowl, or to the fork tines, when these are created from different materials.

Criss-cross matte engraving: In terms of technique, identical to diamond point engraving, but with a design made up of small squares.

Cuff: Juncture or assembly point of the flatware handle and spoon bowl or fork tine.

Damascening: Technique consisting of inlaying a metal wire or plate in a hollowed out metal surface.

Dormant: Sometimes designated the centerpiece, or more often the display tray on which the tureen is placed.

Electrolytic gilding or silverplating: Technique discovered in the early 1840s, whose industrial application was developed by Christofle. The object to be gilded or silver plated is joined to the anode of an electric battery. Precious metal leaf is connected to the cathode and the molecules of the leaf dissolve when exposed to an electric current.

Electroplating: Technique through which a shape can be obtained by means of an electrolytic deposit on a mold that conducts electricity (generally the mold is made of gutta-percha, a derivative of latex, covered in *plombagine*). Today, silver powder and synthetic materials are used.

Enamel in the round: Technique consisting of the application of an opaque or translucent enamel to a three-dimensional form.

Engraving: Technique whereby a burin or acid is used to remove portions of the metal, resulting in a design.

Filigree: Decoration created with metal wires arranged on a metal plate.

Filling: Technique of filling the hollow portion of a flatware handle or utensil using wax or another material that can be melted and that hardens upon cooling.

Guilloche: A decorative pattern made up of rectilinear or intertwining concentric lines, which can be created by machine or by using a lathe.

Hallmark of guarantee: Official hallmark of France, affixed to solid silver, guaranteeing the percentage of alloy. Since 1838, it has depicted a head of Minerva.

Hallmarked: Process of affixing an ornamental motif with the aide of an awl.

Hallmarking: A process consisting of affixing a hallmark. Also used to describe the group of hallmarks that appears on a piece.

Insculp: To bite into or mark with an awl.

Jurande: A territorial jurisdiction to which silversmiths belonged before the Revolution.

Master's hallmark: A hallmark belonging to each silversmith.

Mercury gilding: Technique consisting of covering an object with a blend of gold dust and mercury. The object is then heated so the mercury disappears and the gold is left in a thin film.

Mokume: A decorative technique, which originated in Japan and was rediscovered by Christofle, whereby different metals are laminated using heat, producing a sort of metallic marble effect, veined with different materials and colors.

Paillette: A thin sliver of shiny metal, mother-of-pearl, or plastic, which can be sewn onto fabric.

Paillon: A small metal strip; can designate a small piece of solder used by silversmiths, or the copper sheet placed under precious stones or translucent enamel to enhance its brilliance.

Painted enamel: A layer of white or black enamel is applied to a metal plate; then colored enamels are spread on top, using a spatula or brush. To prevent the plate from becoming warped during firing, another layer of enamel is applied to the reverse side.

Planing: Shaped into a metal sheet by manual hammering.

Plaque: Plated, laminating and application of gold or silver leaf onto a plate of non-precious metal (synonym: rolled).

Polishing: A process of rubbing the surface on a lathe, making it possible to obtain a shiny effect.

Punch: A piece of wood attached to a lathe, making it possible to work in repoussage, to shape, or to mold a metal object or plate.

Repousse: Raised decoration on metal leaf, obtained by pushing the metal from the back toward the front, using a shaped tool or a lathe.

Retreinte: A technique for hammering and working metal leaf into a hollow shape by applying it to a convex form.

Shaft: Portion of a handle between the tip and the fork tine or spoon bowl.

Silver-smithery and gold-smithery: The working of precious metals, with the exception of jewelry-making, and, by extension, silver plated and gilded metal. The term also designates the totality of pieces created by a silversmith or goldsmith.

Silverware: Tableware, and accessories in silver.

Spoon bowl: Hollow part of the spoon.

Stamping: Shaped by hammering a metal plate placed upon a hollow form.

Table centerpiece: Created in the 17th century. This was originally the only piece that remained on the table at the beginning and end of a meal. Condiments were assembled here. In the 19th century, the term designated a grouping of decorative pieces (dishes, candelabra, etc.) placed symmetrically around a central piece (a jardiniere, etc.).

Tine: Prongs, and base of the toothed portion of the fork.

Tip: The wide portion at the end of the flatware handle.

Toothed-wheel decoration: Decoration executed on a lathe with the help of a toothed steel wheel where the edge is embellished continuously, for example with an abstract or plant motif.

Translucent enamel: Technique of covering an engraved metal surface with a layer of translucent enamel, allowing the design to show through the color.

Trefoil: Used to describe a handle that ends in three lobes.

Vermeil: Solid silver gilded in fine gold. Since 1983 this term has also been used to designate solid silver gilded by electrolysis (with a legal minimum thickness).

Yataghan (blade): A sharp, curved blade evoking the type associated with Turkish sabers.

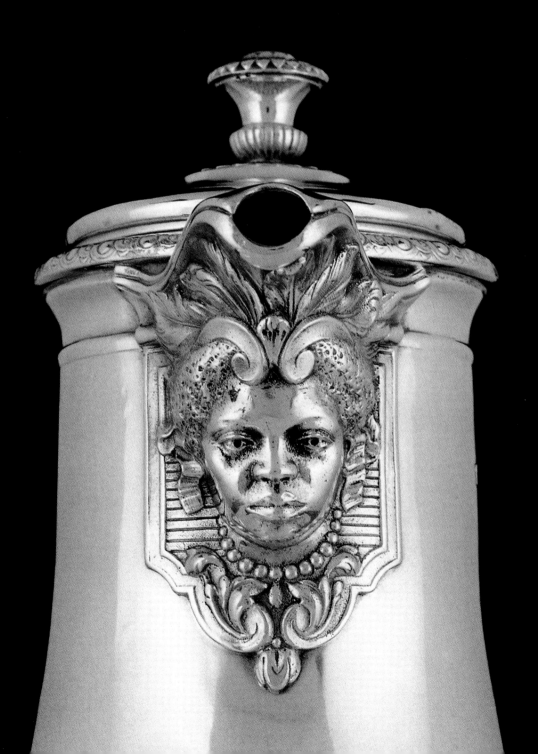

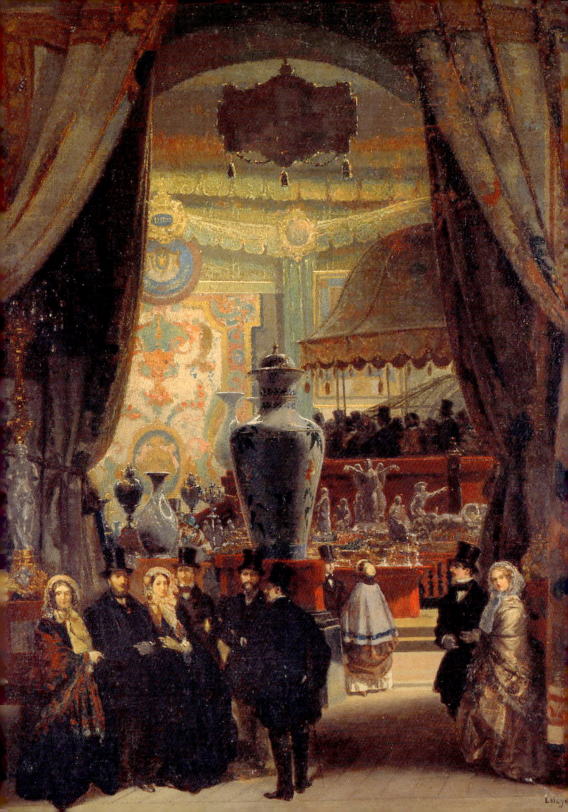

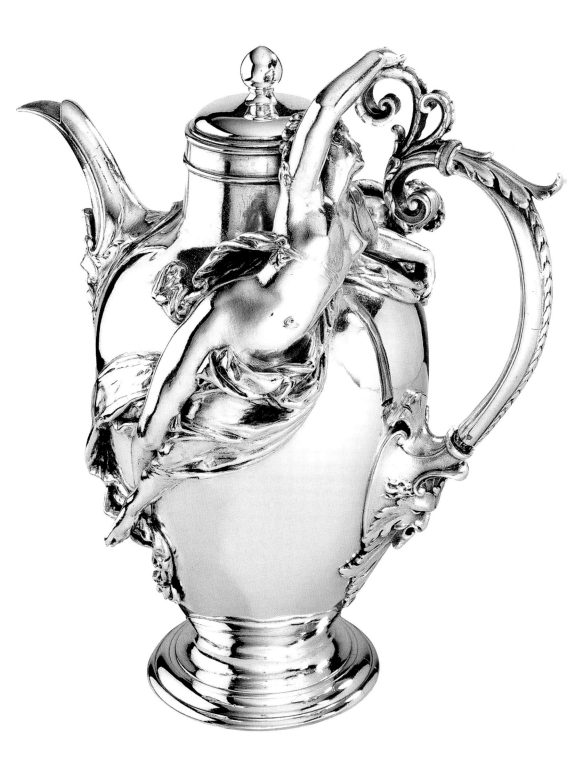

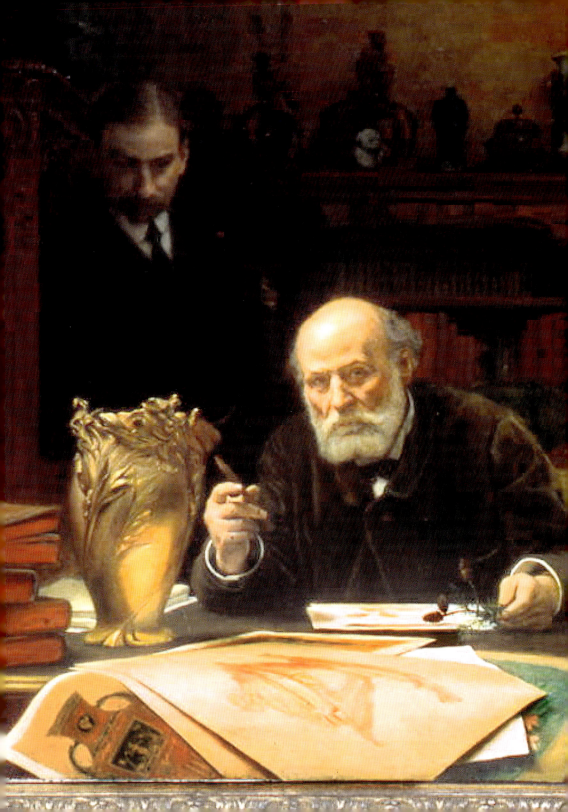

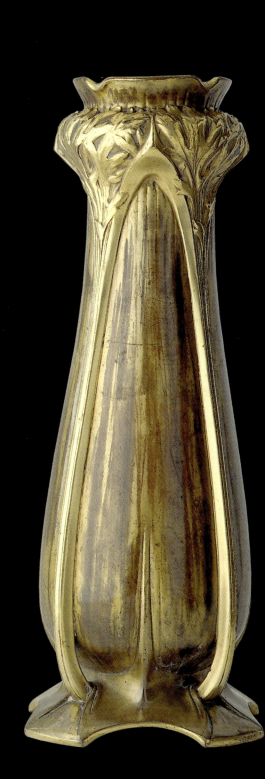

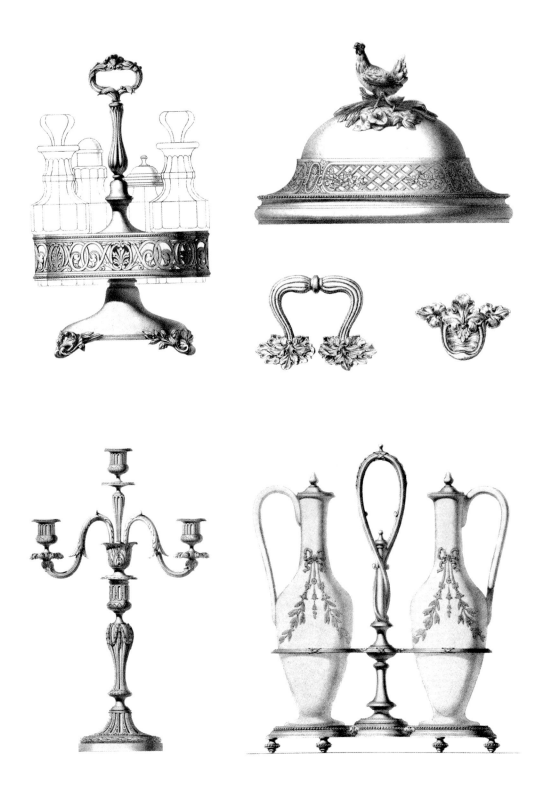

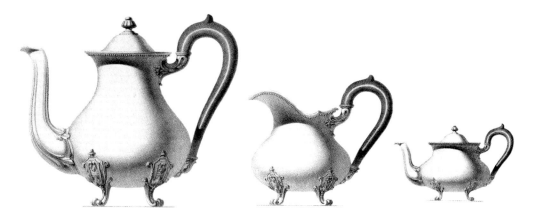

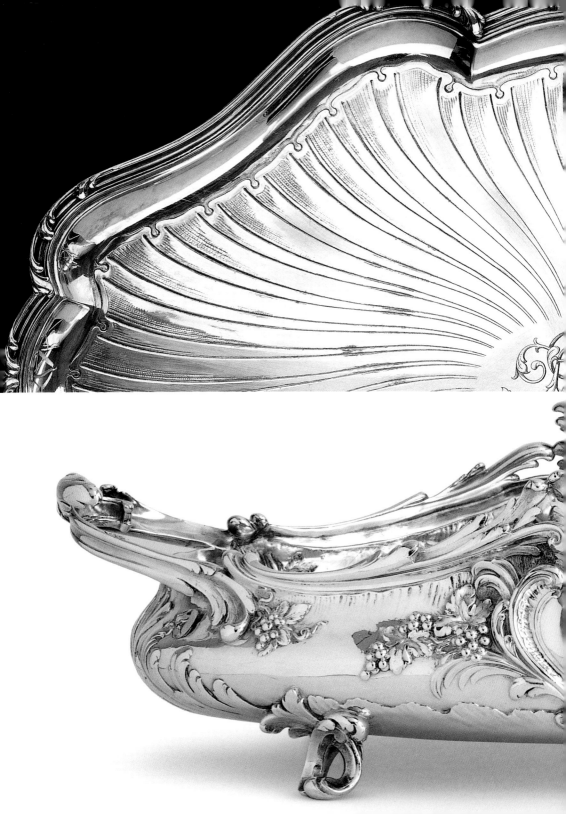

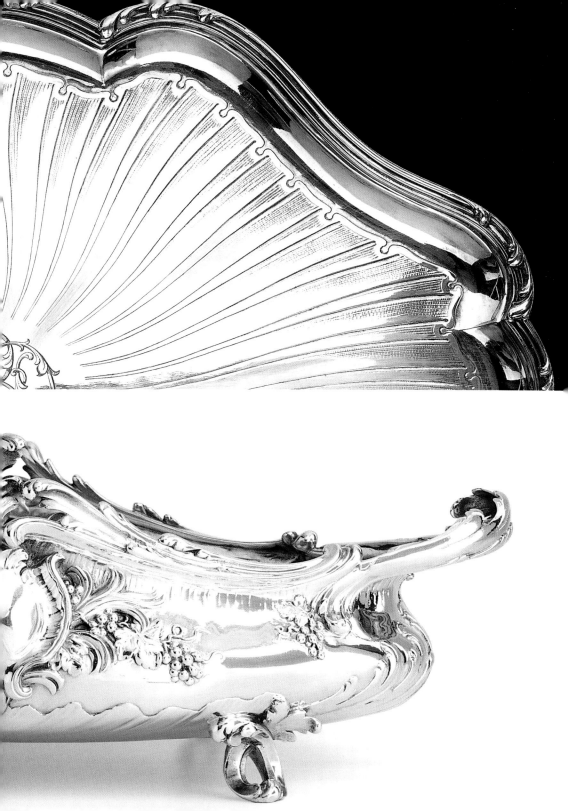

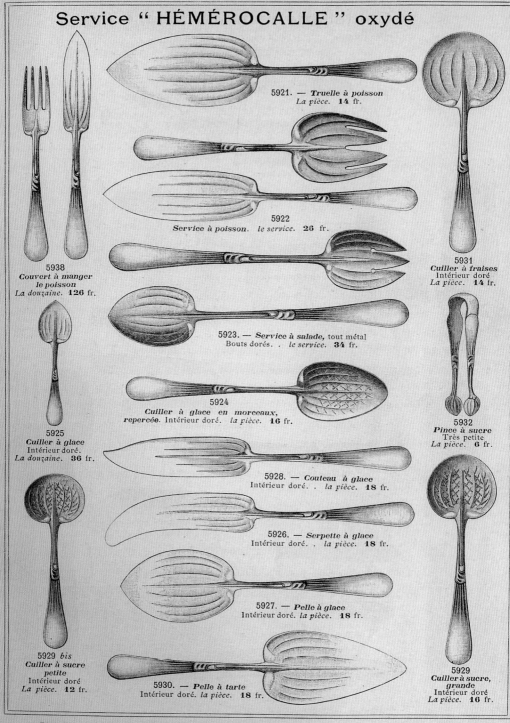

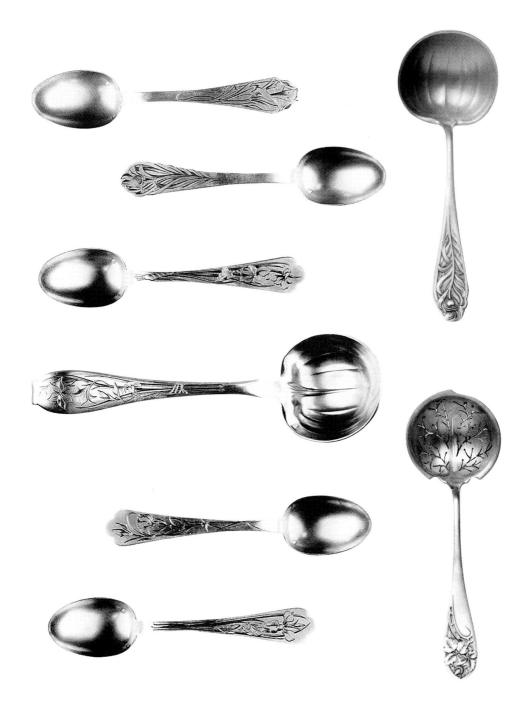

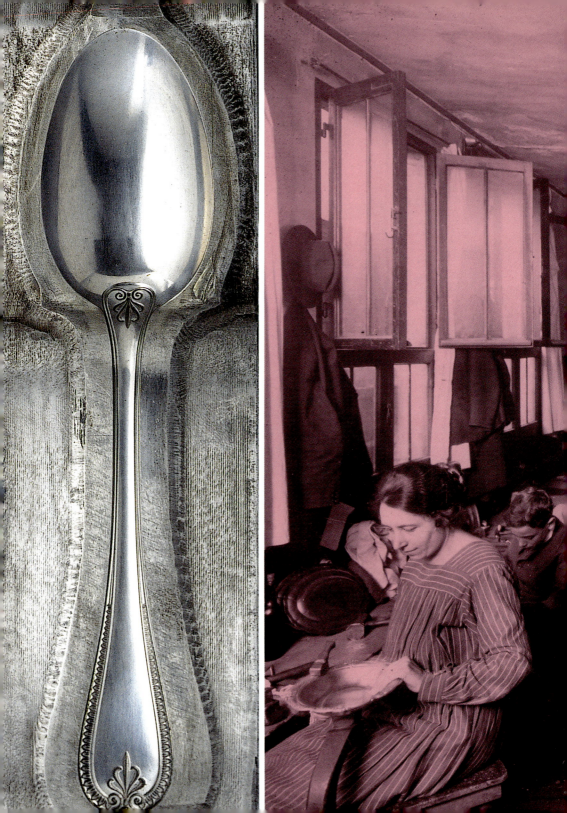

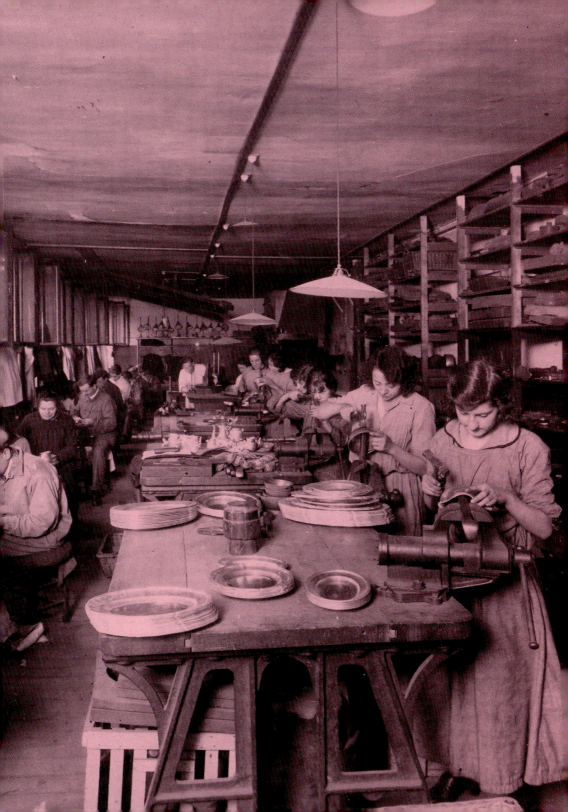

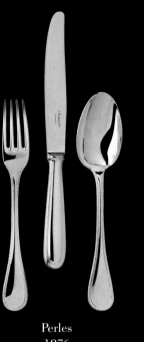
Perles
1876

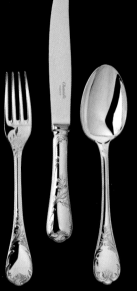
Marly
1897

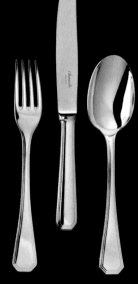
América
1933

Aria
1985

Urban
2004

Ténéré
2004

Renaissance
1960

Malmaison
1967

Albi
1968

Hekla
2005

B.Y
2005

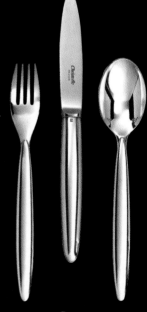
Drop
2005

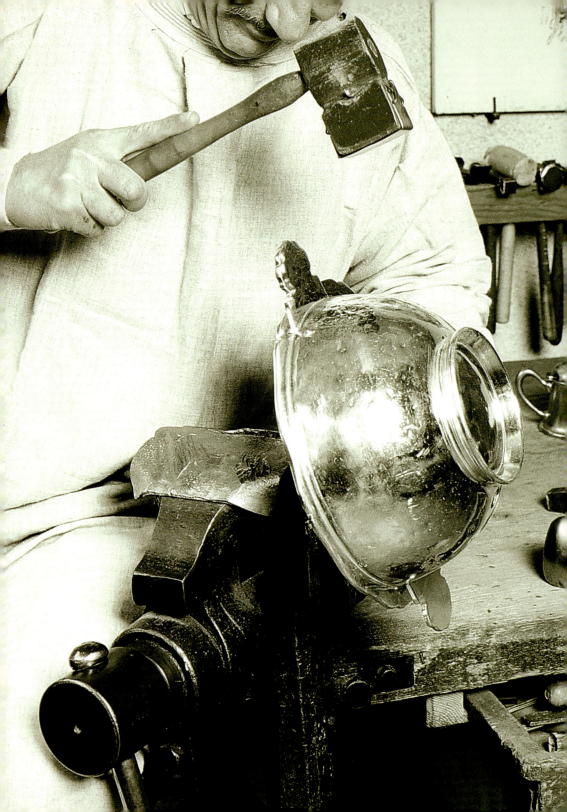

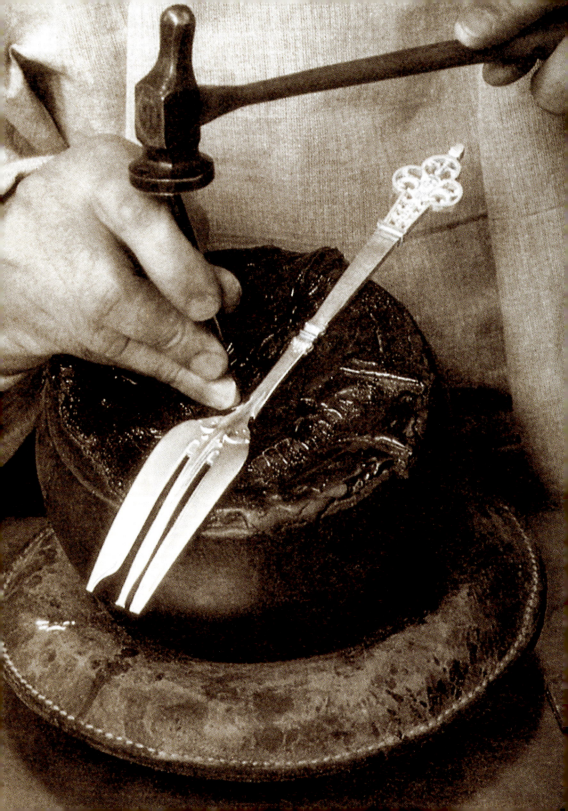

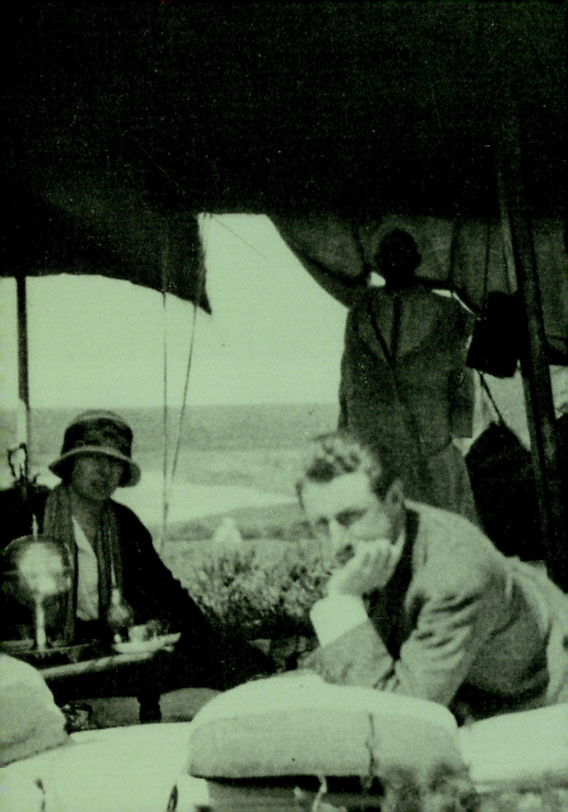

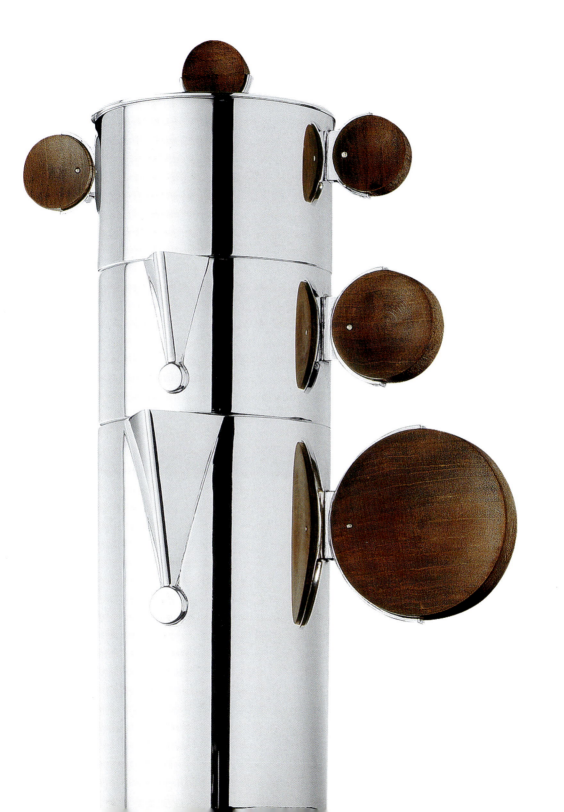

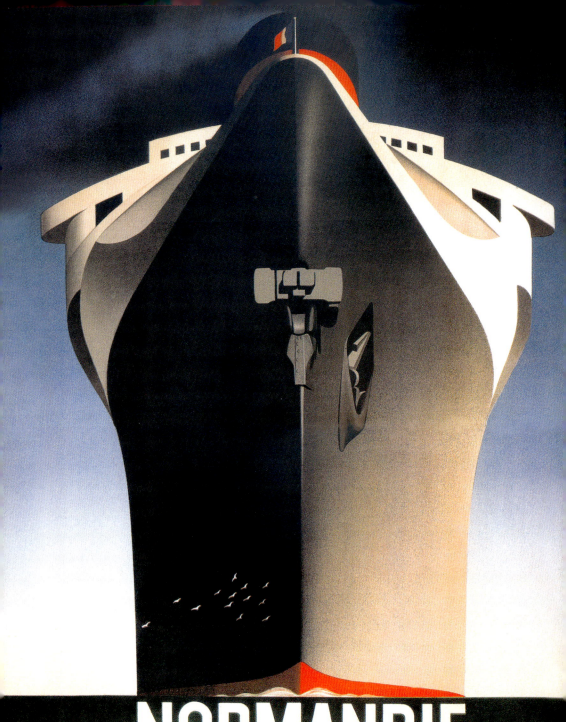

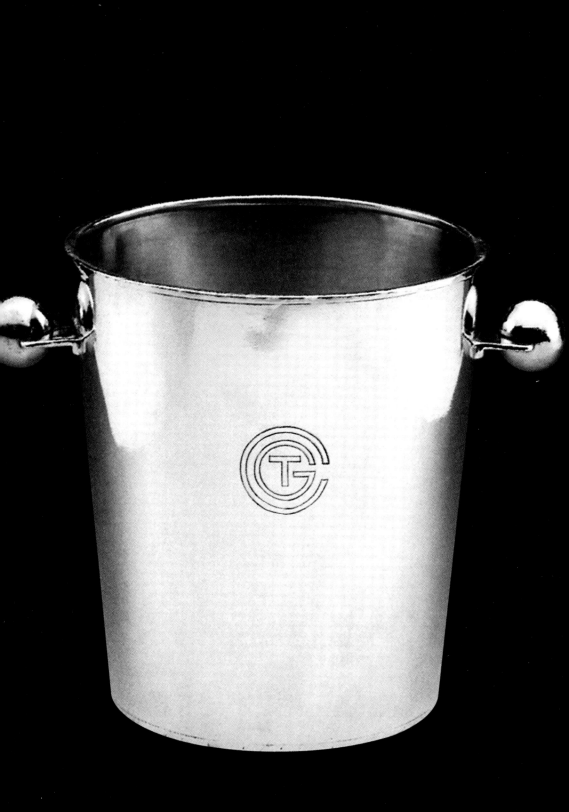

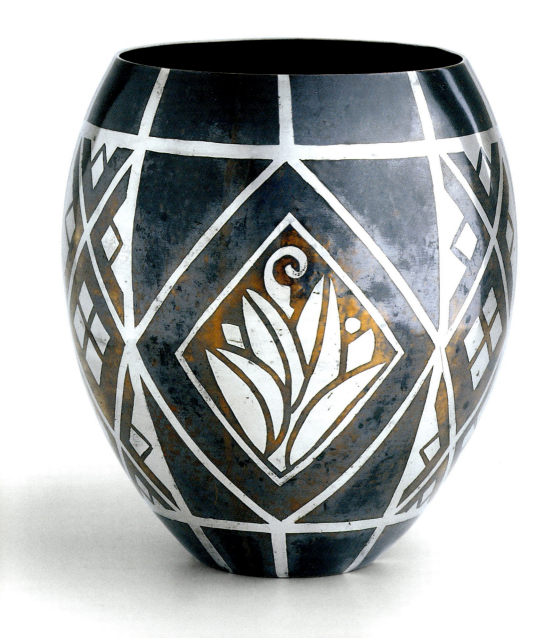

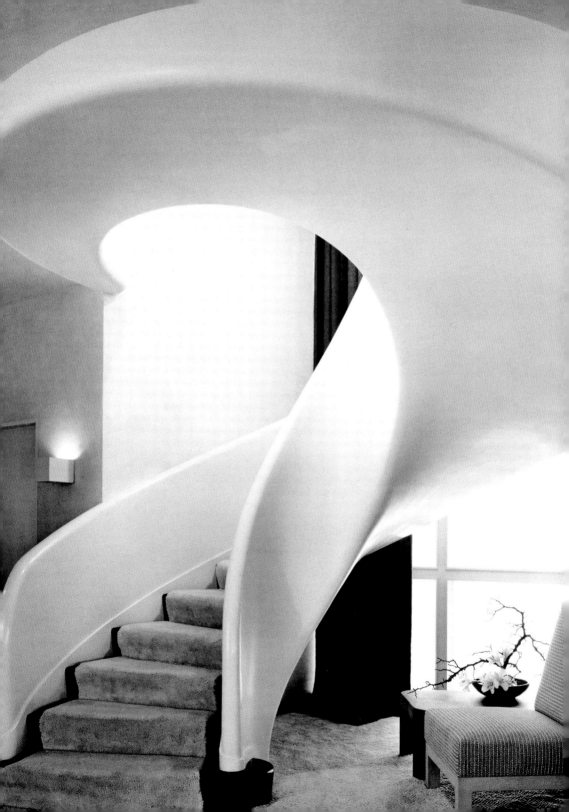

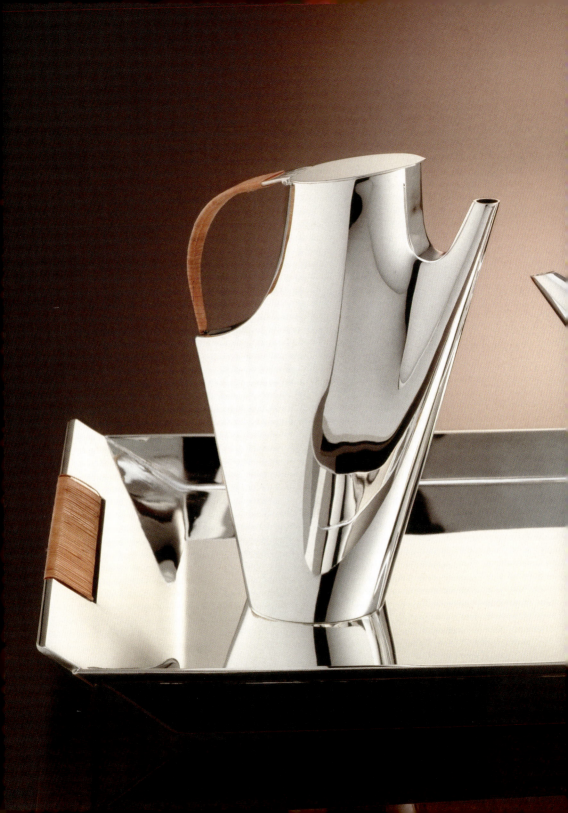

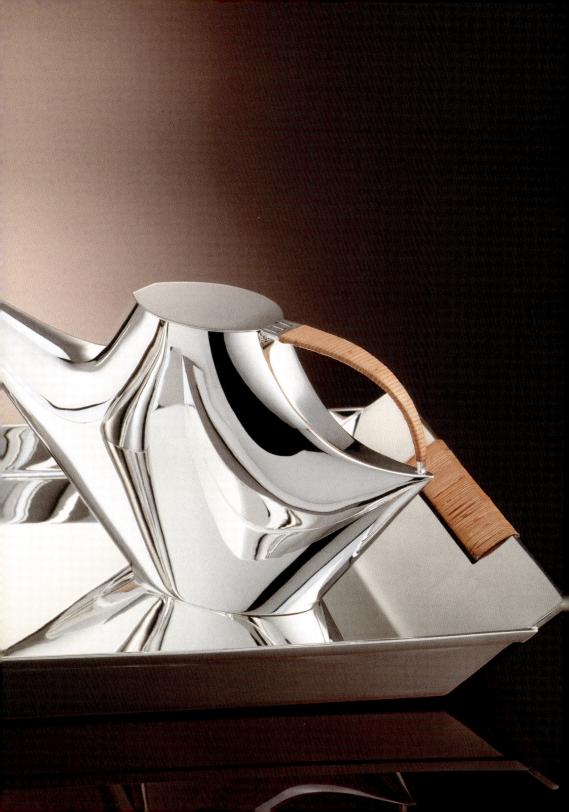

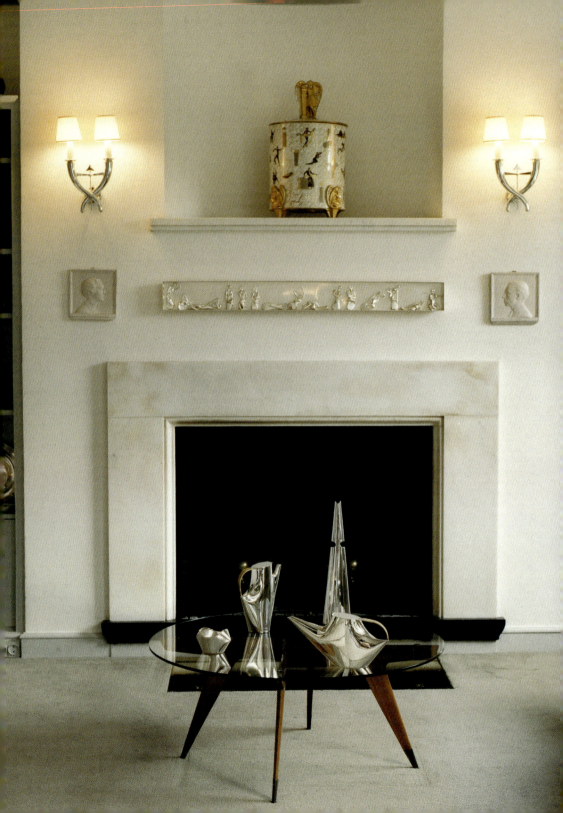

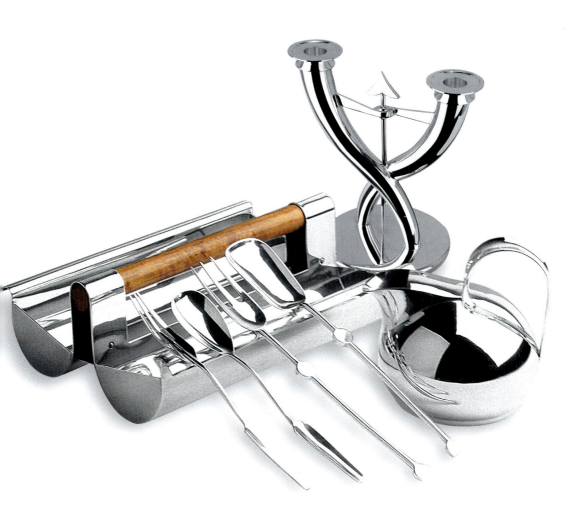

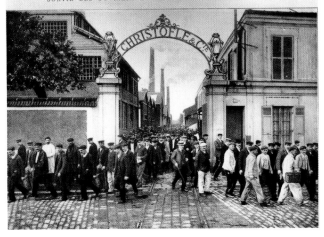
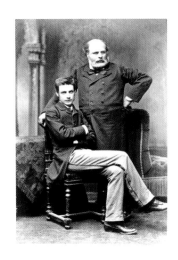
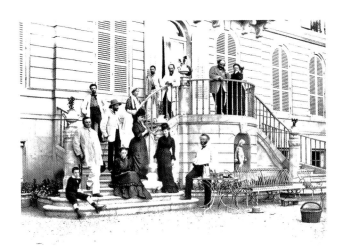

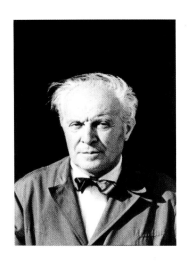

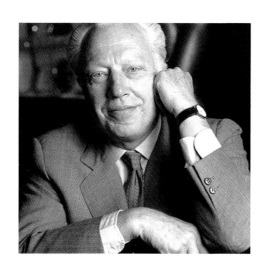
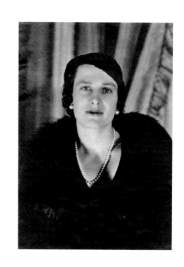
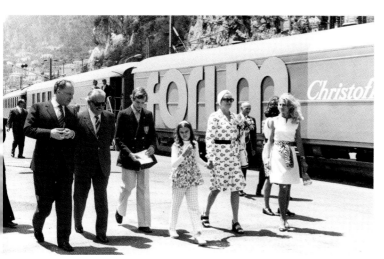

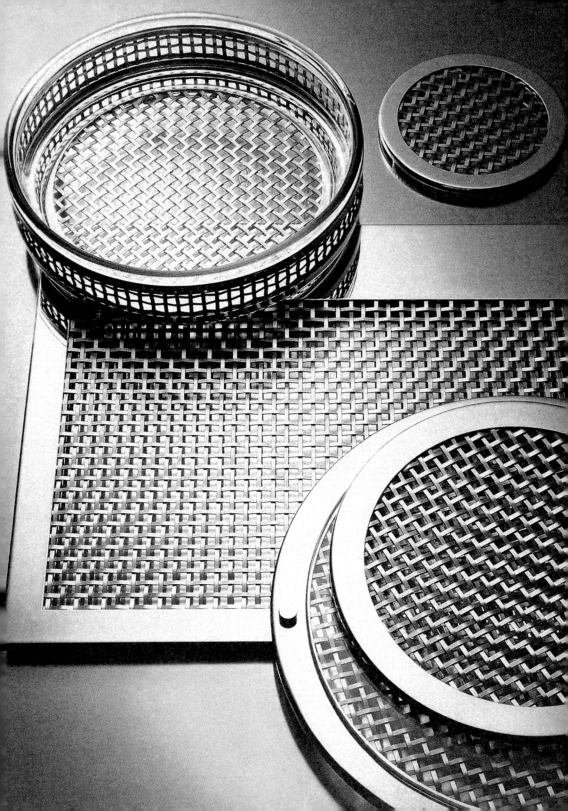

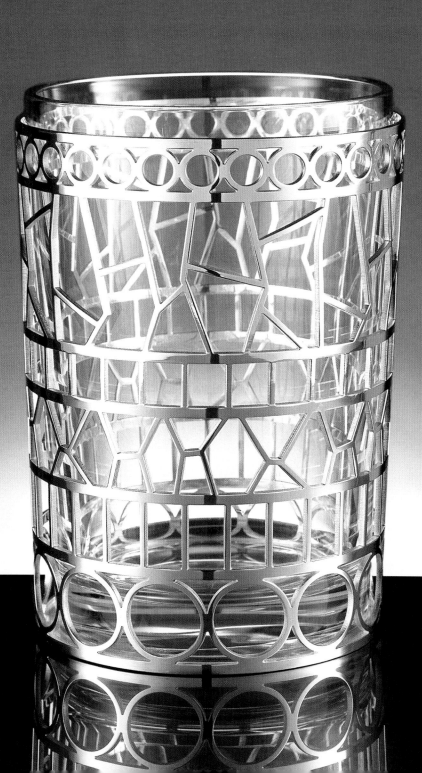

le couteau peut reposer sur le fil.

gorge taillée en biais

le dos du manche doit être plat

113 lame

235

122 manche

8

16

Cylindre d'acier parfait à respecter rigoureusement

Projet de couvert "Intépale"
Christofle Janvier 1990

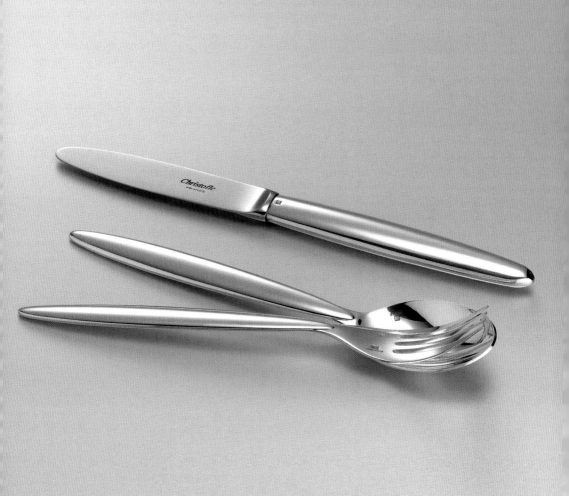

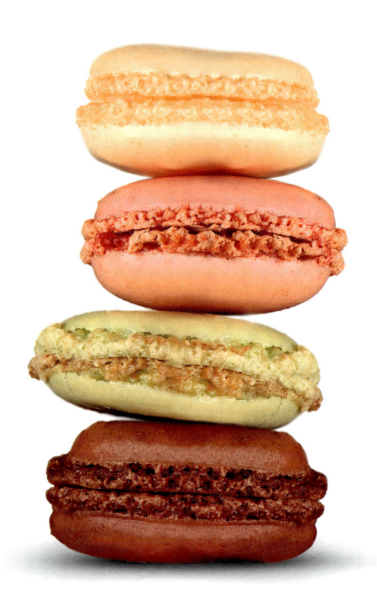

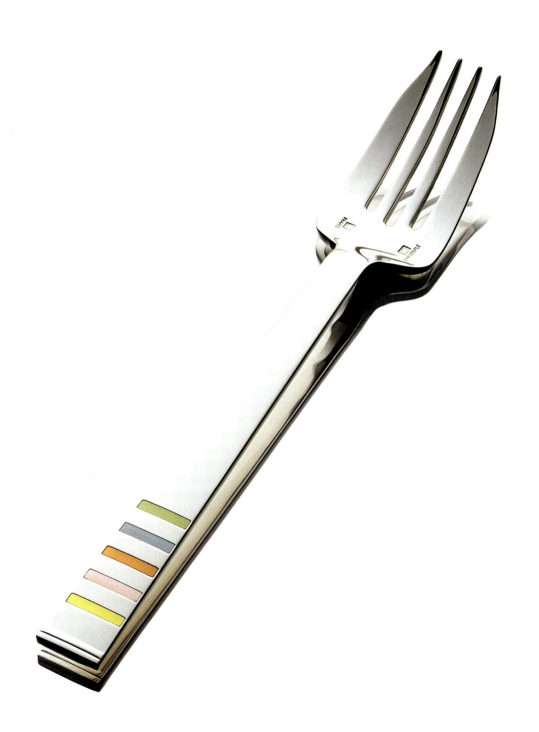

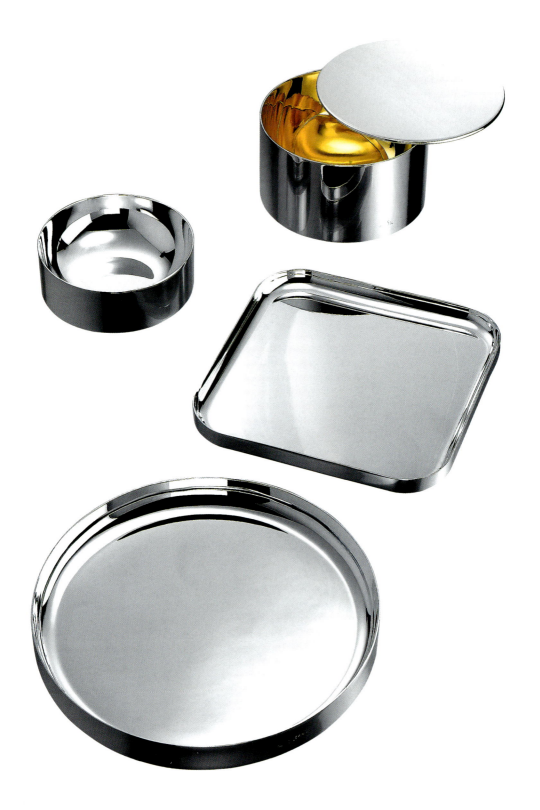

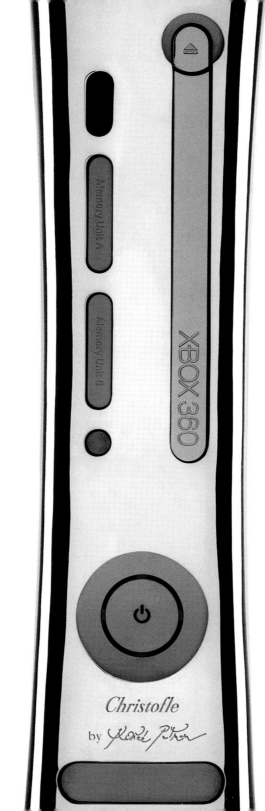

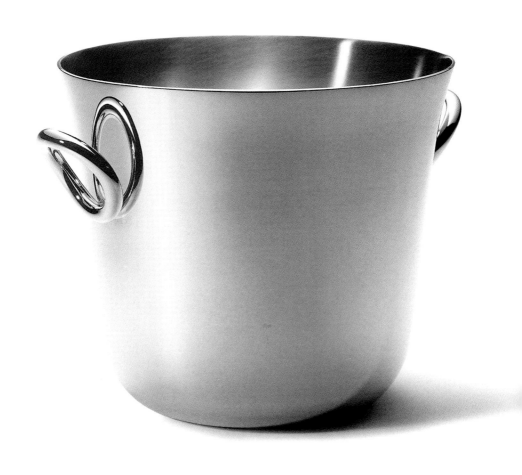

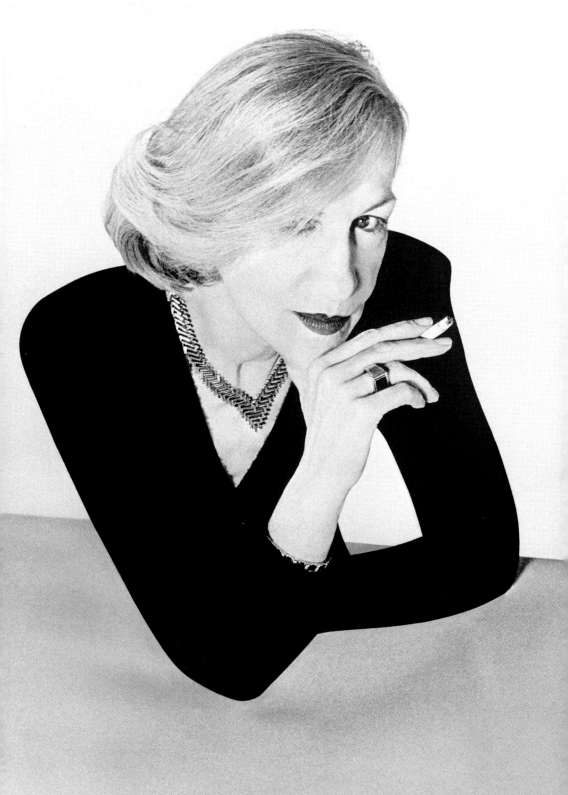

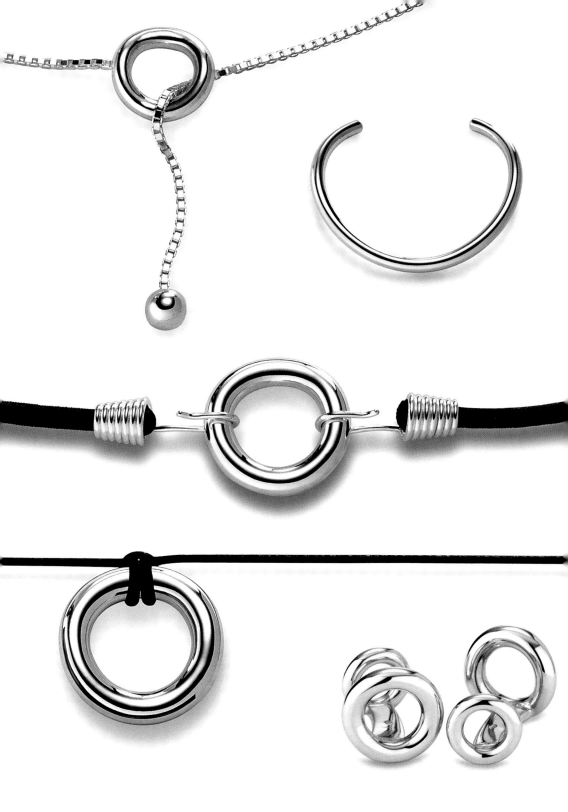

1865 GUERRE SECESSION 1863 METRO LONDRE
ABOLITION ESCLAVAGE 1837 REINE VICTORIA 1831 BE
1827 PHOTO 1804 NAPOLEON 1800 UNION JACK
VOLUTION FRANÇAISE 1786 MOZART 1776 USA 1774
1735 SIDERURGIE 1721 PIERRE LE GRAND 1715 L
RPUS 1665 MOLIERE 1636 HARVARD 1632 REMBRA
610 HENRI IV 1608 QUEBEC 1598 EDIT DE NANTES 156
ERNIC 1520 CAFE CHOCOLAT TABAC 1519 LEONAR
2 CHRISTOPHE COLOMB 1440 GUTENBERG 1431 JEA
IRE EUROPE 1337 GUERRE DE CENT ANS 1275 MARCO
OGNE OXFORD 1200 LUNETTES 1184 INQUISITION 1095

IIe MILLENAIRE

NS D'HUMAINS 987 HUGUES CAPET 970 CHIFFRE
CAIRE 962 SAINT EMPIRE ROMAIN GERMANIQUE
UE GRANDE MOSQUEE 910 ABBAYE DE CLUNY 900
GONOMETRIE 882 RUSSIE 858 JAPON FUJIWAR
E 795 RAIDS VIKINGS 794 KYOTO 756 1e ETAT
ILLE DE POITIERS 711 CONQUETE ESPAGNE 700 C
R LATIN 683 HORLOGE MECANIQUE 651 CORAN
EN CHINE 568 LES LOMBARDS ITALIE 538 BO
TINOPLE 500 LE ZERO 498 CLOVIS 476 F
IN 344 BASILIQUE ST PIERRE 32
271 BOUSSOLE 200
MPIRE KUSANA IN
70 TITUS

Chronology

1793: André Christofle, a manufacturer of "paillettes and metal strips" living in the Marais district of Paris, founds his own company.

1804: Registration of first hallmark of master "Christofle," by Isidore Christofle, silversmith and brother of André Christofle.

1805: Birth of Charles Christofle, son of Anne-Henrie Christofle (sister of André and Isidore).

1820: Charles Christofle begins apprenticeship with his brother-in-law, Parisian jeweler Hugues Calmette.

1830: Charles Christofle takes over Hugues Calmette's business.

1842: Purchase of patents from Englishmen Henry and Georges-Richards Elkington and Frenchman Henri de Ruolz in order to make use of the process of gold-plating and silver-plating by electrolysis.
Opening of a large factory on the Rue de Bondy, in the République district of Paris.
This is one of the very first factories in the world to use electricity.
Christofle does custom work for various silversmiths.

1844: Genesis of "Christofle," silver-plated metal using an electrolysis process.

1845: Charles Christofle founds "Charles Christofle et Compagnie," along with several associates. He decides to stamp all silver-plated metal pieces with a hallmark in order to guarantee quality and moreover because he finds himself compelled to take legal action against numerous rival imitators.

1846: First important official commission: Louis-Philippe orders a silver-plate service for his residence at the Chateau d'Eu, in Normandy.
Christofle becomes purveyor to the Orléans family.

1847: Opening of the Pavillon de Hanovre, on the boulevard des Italiens in Paris. To maintain this reference, Christofle shops still go by the designation "pavillion."

1851: Napoleon III orders a service for the Chateau des Tuileries.
Christofle is named "silversmith to the king" and "purveyor to the emperor."
First World's Fair held in London, where Christofle receives a prize medal, the first in a very long succession of prizes and awards.

1852: Henri Bouilhet, nephew of Charles Christofle, joins the company upon leaving the École Normale. A graduate of the École Centrale des Arts et Manufactures and both an engineer and an artist, he perfects the industrial use of the electroplating process.

1854: Opening of a factory in Karlsruhe, Germany.

1855: Emperor Napoleon III appoints Charles Christofle official purveyor to the court.

1860: Jules Garnier discovers one of the world's largest natural deposits of nickel in New Caledonia.
In France, a law is passed requiring hallmarks for pieces of silver plate.

1863: Death of Charles Christofle.

1866: The Emperor Napoleon III commissions a vermeil service from Christofle.

1867: In Paris, on the occasion of the World's Fair, Christofle shows its first cloisonné enamel work, with a series of Japanese-inspired silver plate.

1868: Christofle responds to a call for bids issued for the fabrication of the statue for the church of Notre-Dame-de-la-Garde, which became the world's largest electroplate piece.

1869: Creation of the monumental electroplated pieces for the Paris Opera.

1876: Christofle enters into an exclusive agreement with Jules Garnier to use his nickel ore.
Opening of the Saint-Denis factory, which is still in operation. Today it is dedicated to the manufacturing of *haute orfèvrerie* (following the example of haute couture). It also contains a museum devoted to the history of the company. The archives, open to the public upon appointment, include nearly 40,000 documents.

1880: On the occasion of the Metal Arts Exhibition in Paris, Christofle shows an exceptional piece designed by sculptor Henri Carrier-Belleuse: a coffeepot called *L'Union fait le*

Pyramidion, *created by Roger Tallon, Christofle, 1999. © Archives Christofle.*

	succès (success through unity), the design of which announces art nouveau. Introduction of the "natural imprints" collection.
1882:	Christofle receives the commission for the renowned "nawab bed," the creation of which requires, among other things, nearly 640 pounds of solid silver.
1883:	Christofle outfits the Orient Express.
1897:	Christofle opens an establishment at 12 rue Royale in Paris, which remains there until 1992, when it moves to number 9 rue Royale.
1898:	To create objects for their art nouveau line, Christofle develops a new alloy, gallia. Christofle outfits the Ritz.
1900:	Presentation of the *Pivoine* (Peony) lamp, an art nouveau masterpiece, where the opaline sphere is blown directly on the mounting. Participation in the World's Fair.
1917:	Launching of the copperware collection, in production until 1938.
1921:	Closing of the Karlsruhe factory.
1924:	Opening of the Mussoco (Italy) and Pesseux (Switzerland) factories.
1925:	Christofle participates in the Exhibition of Decorative and Industrial Arts.
1928:	Gio Ponti creates the *Fleche* (arrow) candelabra, whose forms foreshadow '70s design.
1932:	Tony Bouilhet is named head of Christofle.
1933:	Fjerdingstad creates the classic *Cygne* (swan) gravyboat, which is still in production.
1935:	Christofle creates a 45,000 piece service for the *Normandie* ocean liner.
1939–1945:	Collapse of the silver market. Machinery confiscated by the German occupation forces. Tony Bouilhet and his wife approach their artist friends (Cocteau, Man Ray, Françoise Gilot and others) about creating a series of painted plates.
1951:	On the occasion of the Milan Triennale, Christofle exhibits his "Design" creations, the basis for the Formes Nouvelles (new forms) collection. First expansion of the Pavillons Christofle chain, devoted to tableware.
1952:	Tony Bouilhet calls upon his son Albert to oversee the establishment of a factory and a new branch in Argentina.
1957:	Lino Sabattini creates the Formes Nouvelles collection, which includes the famous Como tea and coffee service.
1959:	Henri Bouilhet is named creative director, a position he holds until 1993.
1969:	Albert Bouilhet becomes president of Christofle.
1970:	President Pompidou chooses the Mercury service for the presidential airplane.
1971:	Opening of an ultramodern manufacturing facility in Yainville, Normandy, solely for the production of flatware. The factory is able to produce five million pieces annually.
1976:	Opening of numerous branches abroad (Spain, Brazil, Germany and elsewhere). The expansion plans are successful and Albert Bouilhet receives the exporting Oscar.
1988:	Creation of a porcelain line where the decoration evokes engraving and chasing processes specific to silversmithery.
1989:	Launching of the Perspective collection, a limited edition of silver pieces created in collaboration with prestigious designers and artists.
1993:	At the age of 26, Maurizio Borletti is named president of Christofle.
Since 1997:	The company works with internationally renowned designers, such as Sylvain Dubuisson (liturgical objects for Pope Jean-Paul II, 1997; Globe for the world cup in soccer, 1998), Roger Tallon (*Pyramidion*, 1999), Adam D. Thihany (Collection 3000, 2000), Clara Halter (*Egg of Peace*, 2001), Gae Aulenti (Metropolis collection, 2001), Martin Szekely (Reflet collection, 2001; Ténéré collection, 2003), Andrée Putman (Vertigo collection, 2002, and *925* collection, 2005), Michele Oka Doner (Palm collection, haute orfèvrerie, 2003, and *Palmaceae* collection, 2005), and Garouste and Bonetti (Ovide collection, 2004).
Early 2004:	After restructuring its capital, the company moves in a new direction.

Glamour Attitude, Christofle advertisement, Publicis 133 creation, 2004. © Archives Christofle.

Christofle

Designs for engravings, monograms, letters, and coats of arms, Christofle catalogue, 1862. © Archives Christofle.
Coffeepot spout (detail) designed for the Hôtel Crillon, Paris, 1909. © Archives Christofle.

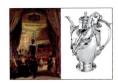

Visit by Napoleon III to the Christofle stand during the 1855 World's Fair in Paris. Lafaye, c. 1855. Oil on canvas. © Archives Christofle.
L'Union fait le succès (Success through Unity) coffeepot, designed by Albert-Ernest Carrier-Belleuse, Christofle, 1880. Gold medal at the Art du Metal exhibition (Paris, 1880), shown at the World's Fairs of 1889 (Paris), 1893 (Chicago), 1900 (Paris), and 1910 (Buenos Aires). © Archives Christofle.

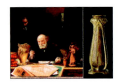

Henri Bouilhet and his son in the office of the Bondy factory. Portrait of Louis-Édouard Fournier, 1910. Oil on canvas. © Archives Christofle.
Anthémis vase, Christofle, 1912. © Archives Christofle.

Nawab's Bed, Christofle, 1882. © Archives Christofle.

Christofle catalogue, excerpt, c. 1855. © Archives Christofle.

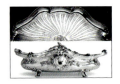

Louis XV oval tray, curved edges, Christofle, 1886. World's Fair, 1889 and 1900, Paris. © Archives Christofle.
Louis XV oval jardiniere, vine pattern, Christofle, 1886. 1889 World's Fair, Paris. © Archives Christofle.

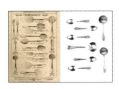
Christofle Catalogue (excerpt), **Hémérocalle service**, 1895 (service flatwares), 1905 (table flatwares). © Archives Christofle.
Sugar ladle and teaspoons, foliage and floral motif, 1899; **sugar sifter**, hazel handle, 1900. © Archives Christofle.

Die stamp for a tablespoon, Malmaison pattern, Christofle. © Archives Christofle.
Planishing workshop, Christofle factory, rue de Bondy, 1925. © Archives Christofle.

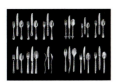
Left to right, top to bottom: Perles flatware, 1876; Marly flatware, 1897; America flatware, 1933; Renaissance flatware, 1960; Malmaison flatware, 1967; Albi flatware, 1968; Aria flatware, designed by Bernard Yot, 1985; Urban flatware, by Adam D.Tihany, 2004; Ténéré flatware, by Martin Szekely, 2004; Hekla flatware, by Dögg Gudmundsdóttir (Dögg Design), 2005; B.Y flatware, by Bernard Yot, 2005; Drop flatware, by Christian Biecher, 2005. © Archives Christofle.

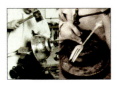
Planishing workshop. © Archives Christofle.
Chasing workshop. © Archives Christofle.

Tony Bouilhet in a caïd's tent, c. 1930. © Archives Christofle.
Gigogne coffeepot, designed by Christian Fjerdingstad, 1926. © Archives Christofle.

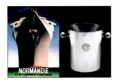
The Normandie ocean liner, poster by Cassandre, 1935. © Rue des Archives.
Transat champagne bucket, first class section of the Normandie, Luc Lanel for Christofle, 1933. © Archives Christofle.

Cartouche vase with foliage motif, brown and black patina, designed by Luc Lanel, copperware collection, Christofle, 1924. Exhibition of Decorative and Industrial Arts, Paris, 1925. © Archives Christofle.
Stairway designed by the architect Samuel Max, 1945. © Chicago Historical Society.

Como coffee service, designed by Lino Sabattini, 1957. © Archives Christofle.

L'Ange Volant (The Flying Angel), house designed by Gio Ponti for Tony Bouilhet in 1927. © Noëlle HOEPPE for Elle Décoration.
Flèche candelabra and coffeepot by Gio Ponti, flatware by Lino Sabattini, basket by Christian Fjerdingstad. © Archives Christofle.

Bookcase for the Pompidou apartments at the Élysée palace, designed by Pierre Paulin, 1968-1972. © Archives Pierre Paulin/All Rights reserved.
Mercury coffeepot, Christofle Contemporary Collection, selected by President Georges Pompidou for the presidential jet, Christofle, 1970. © Archives Christofle.

Left to right, top to bottom: **workers leaving the Christofle factory**, Saint Denis, 1908; **André and Henri Bouilhet**, c. 1885; **Albert Bouilhet**; **Carla Bouilhet**, née Borletti, in 1933; **the Bouilhet and Christofle families** at Château de Soulins, c. 1870; **Tony Bouilhet**, c. 1940; **the Christofle Train Forum**, touring exhibition, June 1973, Monaco; **Christian Fjerdingstad**, c. 1935; **Lino Sabattini**, c. 1957; **Gio Ponti**, c. 1957. © Archives Chrisofle; **Martin Szekely**, 2004. © photo Dimitri Tolstoï; **Andrée Putman**. © photo Brigitte Baudesson.

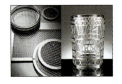
Métropolis Collection, designed by Gae Aulenti, 2001. © Archives Christofle.
Ovide vase, designed by Garouste and Bonetti, 2004. © Archives Christofle.

Intégrale knife, drawing, Bernard Yot, Christofle, 1990. © Archives Christofle.
Drop flatware, designed by Christian Biecher, 2005. © Archives Christofle.

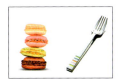

Macaroons at the Pierre Hermé shop. © Photo Jean-Louis Bloch Lainé.
Dessert fork, designed by Christofle for Pierre Hermé, 2003. © Archives Christofle.

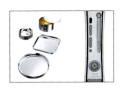

Reflets collection, designed by Martin Szekely, 2001. © Archives Christofle.
X Box, removable solid silver front, "Christofle by Andrée Putman" (limited edition) © Archives Christofle.

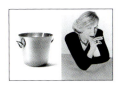

Champagne bucket, Vertigo collection, designed by Andrée Putman, 2002. © Archives Christofle.
Andrée Putman. © Photo Serge Lutens.

Palmaceae necklace, designed by Michele Oka Doner, 2005. © Archives Christofle.
Collection 925 jewelry, designed by Andrée Putman, 2005. © Archives Christofle.

The Bouilhet-Christofle Museum

Housed within the Haute Orfèvrerie studios in Saint-Denis, the Bouilhet-Christofle Museum is dedicated to the art of silver, its techniques, styles, and history. With an area of more than 4,800 square feet, the museum contains objects, implements, archives, iconographic documents, and a library. The collection is focused on Christofle's production from its founding, in 1830, to today. It presents not only Christofle's history, but also the techniques applied to silverwork, the evolution of the decorative arts over 175 years, and dining traditions of the nineteenth and twentieth centuries.

The museum is open to the public from Monday to Friday, from 9:30 a.m. to 1:00 p.m. and from 2:00 p.m. to 5:30 p.m. (closed on holidays). The documentation center, which contains 3,000 drawings, 23,000 photographs (from 1851 to 1993), and a 4,000-volume library, is open by appointment only.

Address: 112, rue Ambroise-Croizat, 93 206 Saint-Denis Cedex
Telephone: 01 49 22 40 40; fax: 01 49 22 40 62
www.christofle.com

The editor wishes to thank the Christofle house for its precious collaboration. It also thanks photographer Jean-Louis Bloch Lainé, Sabine Coron (BNF), Serge Darmon (Christophe L.), Anne Gros (Christofle Museum), Michael Stier (Condé Nast), Catherine Terk (rue des Archives), and Maïa Wodzislawska for their help on the realization of this work.

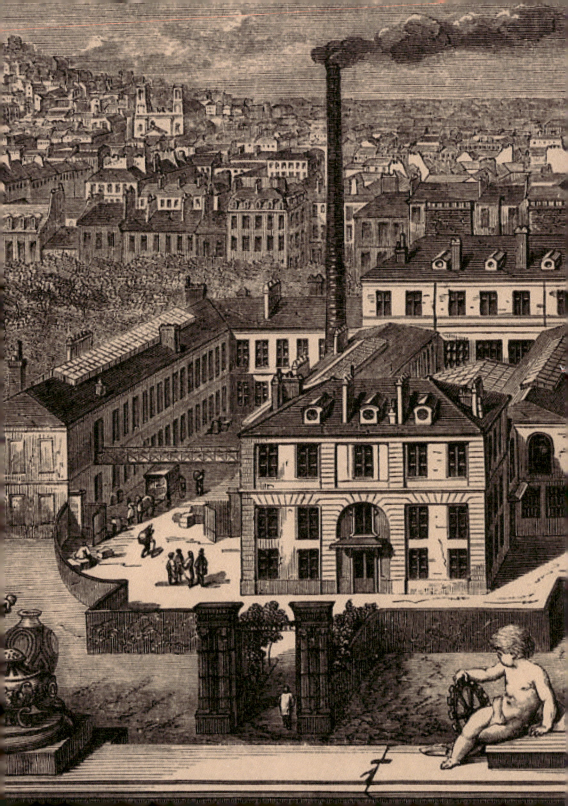